MW00759952

# WOMEN IN THE WORLD OF INDIA

# WOMEN'S ISSUES:
## GLOBAL TRENDS

# WOMEN'S ISSUES:
## GLOBAL TRENDS

## WOMEN IN THE WORLD OF INDIA

Fords Middle School Library
Fanning Street
Fords, NJ 08863

BY
MIRANDA AND WILLIAM HUNTER

**Mason Crest Publishers**
**Philadelphia**

Mason Crest Publishers Inc.
370 Reed Road
Broomall, Pennsylvania 19008
(866) MCP-BOOK (toll free)

Copyright © 2005 by Mason Crest Publishers. All rights reserved. No part of this publication may be reproduced or transmitted in any form or by any means, electronic or mechanical, including photocopying, recording, taping, or any information storage and retrieval system, without permission from the publisher.

First printing
1 2 3 4 5 6 7 8 9 10

Library of Congress Cataloging-in-Publication Data

Hunter, Miranda, 1977–
  Women in the world of India / by Miranda and William Hunter.
      p. cm.— (Women's issues, global trends)
  Includes index.
  ISBN 1-59084-865-9    ISBN 1-59084-856-X (Series)
  1. Women—India—Social conditions. 2. Family—India. 3. Women—Employment—
  India.
  4. Women in development—India. I. Hunter, William, 1971– II. Title. III. Series.
  HQ1742.H86 2005
  305.42'0954—dc22
                    2004006585

Interior design by Michelle Bouch and MK Bassett-Harvey.
Illustrations by Michelle Bouch.
Produced by Harding House Publishing Service, Inc.
Cover design by Benjamin Stewart.
Printed in India.

# CONTENTS

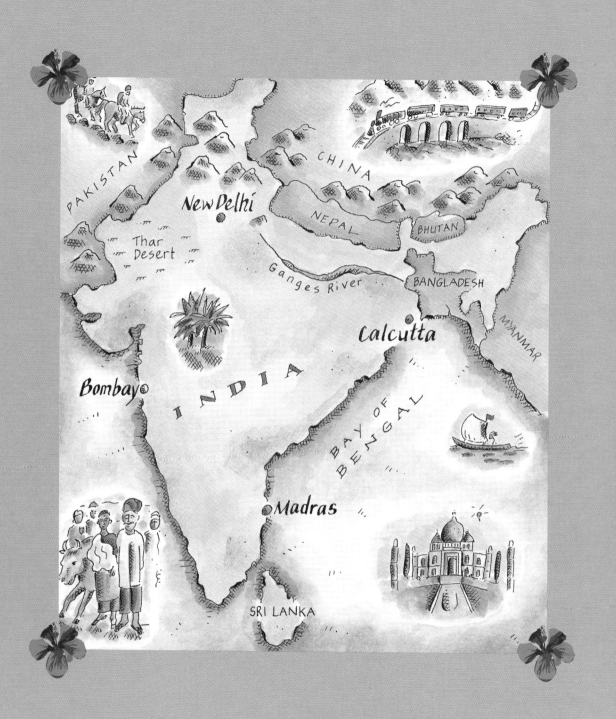

# INTRODUCTION

*by Mary Jo Dudley*

The last thirty years have been a time of great progress for women around the world. In some countries, especially where women have more access to education and work opportunities, the relationships between women and men have changed radically. The boundaries between men's roles and women's roles have been crossed, and women are enjoying many experiences that were denied them in past centuries.

But there is still much to be done. On the global stage, women are increasingly the ones who suffer most from poverty. At the same time that they produce 75 to 90 percent of the world's food crops, they are also responsible for taking care of their households. According to the United Nations, in no country in the world do men come anywhere near to spending as much time on housework as women do. This means that women's job opportunities are often extremely limited, contributing to the "feminization of poverty."

In fact, two out of every three poor adults are women. According to the Decade of Women, "Women do two-thirds of the world's work, receive 10 percent of the world's income, and own one percent of the means of production." Women often have no choice but to take jobs that lack long-term security or

adequate pay; many women work in dangerous working conditions or in unprotected home-based industries. This series clearly illustrates how historic events and contemporary trends (such as war, conflicts, and migration) have also contributed to women's loss of property and diminished access to resources.

A recent report from Human Rights Watch indicates that many countries continue to deny women basic legal protections. Amnesty International points out, "Governments are not living up to their promises under the Women's Convention to protect women from discrimination and violence such as rape and female genital mutilation." Many nations—including the United States—have not ratified the United Nations' Women's Treaty.

During times of armed conflict, especially under policies of ethnic cleansing, women are particularly at risk. Murder, torture, systematic rape, forced pregnancy and forced abortions are all too common human rights violations endured by women around the world. This series presents the experience of women in Vietnam, Cambodia, the Middle East, and other war torn regions.

In the political arena, equality between men and women has still not been achieved. Around the world, women are underrepresented in their local and national governments; on average, women represent only 10 percent of all legislators worldwide. This series provides excellent examples of key female leaders who have promoted women's rights and occupied unique leadership positions, despite historical contexts that would normally have shut them out from political and social prominence.

The Fourth World Conference on Women called upon the international community to take action in the following areas of concern:

- the persistent and increasing burden of poverty on women
- inequalities and inadequacies in access to education and training
- inequalities and inadequacies in access to health care and related services
- violence against women

- the effects of armed or other kinds of conflict on women
- inequality in economic structures and policies, in all forms of productive processes, and in access to resources
- insufficient mechanisms at all levels to promote the advancement of women
- lack of protection of women's human rights
- stereotyping of women and inequality in women's participation in all community systems, especially the media
- gender inequalities in the management of natural resources and the safeguarding of the environment
- persistent discrimination against and violation of the rights of female children

The Conference's mission statement includes these sentences: "Equality between women and men is a matter of human rights and a condition for social justice and is also a necessary and fundamental prerequisite for equality, development and peace. . . equality between women and men is a condition . . . for society to meet the challenges of the twenty-first century." This series provides examples of how women have risen above adversity, despite their disadvantaged social, economic, and political positions.

Each book in WOMEN'S ISSUES: GLOBAL TRENDS takes a look at women's lives in a different key region or culture, revealing the history, contributions, triumphs, and challenges of women around the world. Women play key roles in shaping families, spirituality, and societies. By interweaving historic backdrops with the modern-day evolving role of women in the home and in society at large, this series presents the important part women play as cultural communicators. Protection of women's rights is an integral part of universal human rights, peace, and economic security. As a result, readers who gain understanding of women's lives around the world will have deeper insight into the current condition of global interactions.

"THE WIFE IS HALF, THE MAN, THE BEST OF FRIENDS, WITH A WIFE A MAN DOES MIGHTY DEEDS,

WITH A WIFE A MAN FINDS COURAGE."—AN INDIAN POET

# INDIAN WOMEN THROUGH THE AGES

The year was 1844. The place was Golpapur, a little village near the coast of India, a colony under British rule. In this village lived a small woman who had been married nearly fifty years when her husband Umed died. She grieved very deeply for him and could not imagine her life without him. As a good woman of Hindu faith, she had spent her life serving him. In order to complete her duty, however, she had to take one very final step. This step, this thing she needed to do, was no longer allowed, because the British rulers did not approve. The woman stopped eating and drinking. She would not leave the place where her husband's body would soon be cremated.

The funeral pyre was lighted, and she watched her husband of fifty years burn away. She did not care what the British rulers thought. She removed her jewelry and smoothed the folds of red cloth draped around her body. She gathered up flowers and a basket of rice, as if to go somewhere.

The widow said, "My husband has reached the Sun God now. I have died with him in my past three lives; it is impossible for us to be separate. . . He is right now waiting for me at the wedding alter in heaven." Her heart was

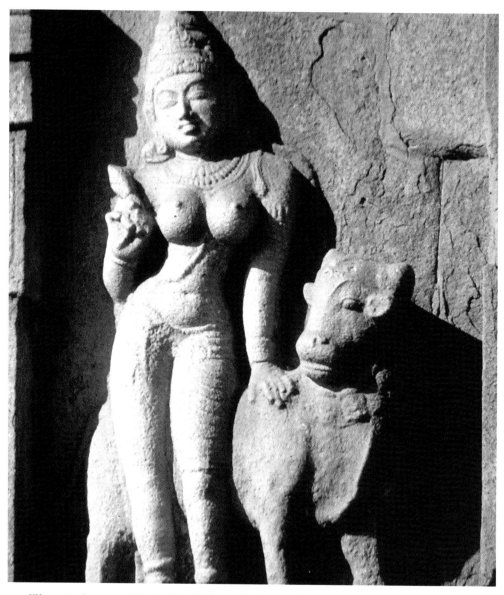

Women in the ancient Hindu culture had more freedom and power than they did in later periods of India's history.

WOMEN IN THE WORLD OF INDIA

beating very quickly, but she was ready. Upon this, her joy knew no bounds. She tossed the flowers on the pyre and jumped into the fire. She turned into ash in no time.

✤ ✤ ✤

The story, adapted from the journal of W.H. Sleeman, "Rumble and Recollections of an Indian Official, 1844", describes the tradition of suttee. Suttee is the ancient Hindu tradition of an Indian wife burning herself alive. She would throw herself on the funeral pyre, a large fire used to burn away the body of a dead person, when her husband died before her. Suttee was considered the ultimate act of love by a wife. Her sacrifice would allow her into heaven and bring all her ancestors' souls to heaven as well. Women who committed suttee were often worshipped as goddesses. Temples were built to honor their actions. Some women committed suttee willingly. Others were less willing. There are many accounts of women fighting tooth and nail as their brothers-in-law forced them into the flames. Around the country, there are stones called Maha-Suttee stones, or hero stones. The stones stand in memory of brave Indian women who gave their life in suttee. The British, who ruled India at the time, officially outlawed suttee in 1829, but the practice continued for many years.

✤ ✤ ✤

Most of the modern culture in India comes from the combination of two ancient cultures. The Indus Valley civilization, also known as the Harappans, ruled India about 5000 B.C. The Aryan tribes roamed the grasslands north of the Himalaya Mountains. These cultures came together in the plains of northern India around 1500 B.C., when the Aryans migrated through the Khyber Pass. This was one of the few ways to get through the very rugged Himalaya Mountains. The Aryans brought horses with them, which allowed their culture to spread rapidly across all of India.

The Aryans composed the four Vedas, or holy poems. The Vedas are one of the many holy texts of the Hindu religion. In the ancient Aryan society, women

had a higher standing than they did in later Indian history. In fact, women wrote some of the Vedas. Traditions relating to women varied across India, and they continued to change throughout history. In the early days of the Gupta Empire, one of the most powerful empires in Indian history, upper-class Hindu women could still go out in public. Some of them even had the opportunity to get good educations. In the later days of the Gupta Empire, upper-class women had less freedom. They were limited to their homes. When they went out in public, they had to cover themselves completely. The poorer women were freer to leave their homes. They worked hard every day, in the fields or making cloth.

Indian developments in mathematics have had a major impact on the entire world. Mathematicians from the Gupta Empire created the system of writing numbers that we use today. We call them "Arabic" numbers. Arabs in India carried them to the Middle East and the rest of the world many years ago. In later years, Indian mathematicians came up with the idea of "zero." They created the decimal system of numbers that children all over the world learn in math class today.

A sculpture portrays India's feminine ideal.

Indians believed that women had creative energy that men did not have. When a couple married, the woman's energy could complete her husband. However, husbands had to focus the energy, or it could become destructive. A woman's most important duties were to marry, devote herself to her husband, and raise their children. These duties defined women's rights. They had little freedom outside the family.

In India, women have historically been considered less worthy than men. Many of the traditions that have deep roots in the cultural history of the country are considered *oppressive* toward women. Suttee is only one example of the traditions that had effects on the status of Indian women. The *dowry* system, for instance, required a bride-to-be to pay a large sum of money or property to

A wall mural in India portrays a female goddess.

WOMEN IN THE WORLD OF INDIA

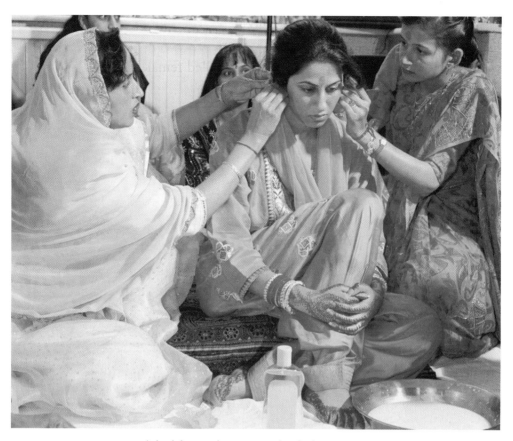

A bride's attendants prepare her for her marriage.

the groom after the wedding. Brides that were unable to meet the dowry demands of their husbands were often *harassed* or hurt after the marriage ceremony. Most marriages were arranged; in other words, the bride would not be allowed to choose her future husband. She also had no control over the size of the dowry, as this was set when the marriage was arranged. Most marriages were planned while the girl was still a toddler, and the marriage usually took place before the girl reached her teenage years. In most cases, the bride's fam-

ily paid the dowry because brides usually had few resources of their own. This fed the belief that female children were more of a financial stress on families than male children. Poor parents sometimes killed female children out of fear that they would not be able to pay the girl's dowry when she married.

When a woman married, she became part of her husband's family. She was no longer legally able to receive any inheritance from her own family. An unmarried Indian woman would not get an equal share of the inheritance if she had brothers, because males pass on the family name. This is a very important part of Indian culture. Upon marriage, the young bride would be expected to learn how to please her new family, which often included the groom's mother,

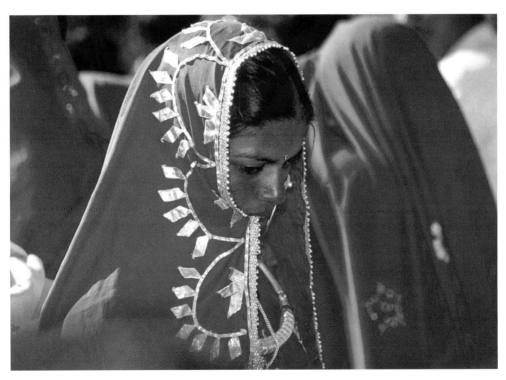

An Indian bride.

WOMEN IN THE WORLD OF INDIA

Religion and rituals are very important to the people of India. Hinduism, Buddhism, Sikhism, and Jainism, which are considered among the world's major religions, all originated in India. Hinduism is the major religion in India. Approximately 80 percent of the country is Hindu. The second most popular religion, Islam, arrived in India during the early part of the eleventh century. Islam had a large effect on the cultures of India, and many of the traditions seen now come from a mix of Hindu and Islam teachings. The Sikh religion, in fact, is a combination of aspects of Hindu and Islam.

father, brothers, and sisters. This was sometimes like slavery for the young bride. She would be forced to cook, clean, and care for the children in the household. Sometimes she would have to work at poor jobs to help her new family make ends meet.

Indian women who did not marry young were often seen as unclean or unfit for marriage. Both the men and women of the community avoided them. Rumors might spread that unmarried women were insane or diseased, or even

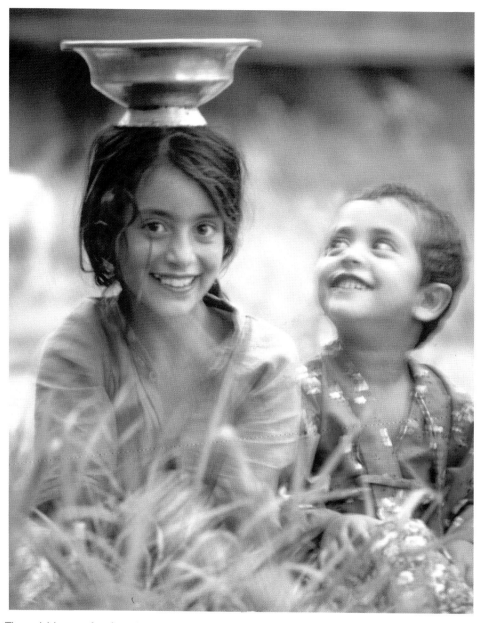

These children are free from the restrictions of adulthood, but many women in India still observe purdah.

WOMEN IN THE WORLD OF INDIA

abandoned by the gods. These women were usually very poor and had trouble getting food or finding a place to live.

If a woman's husband died before her, she was often blamed for the loss and shunned by the whole community. She might be forced to wear ugly clothing and shave her head. In some cases, widowed women were physically abused by groups of men from the community.

Women's dress in India has historically been very conservative. They were expected to have every inch of skin covered by clothing. This custom is known as purdah. In India, the actual translation of the word "purdah" is screen or veil. The tradition of purdah became more popular as Muslims moved into India. Women who did not observe purdah were often abused or ridiculed. Women seen in public with exposed skin were often *subjected* to behavior known in India as Eve teasing. Eve teasing is unwanted touching or harassment of women. It could also lead to physical abuse. Eve teasing can be a serious problem for Hindus, because their religion restricts physical contact in public. People who are touched in public are often required to be cleansed, or blessed, by a priest. This issue is most commonly associated with the Hindu belief in a caste system. If a member of a higher caste were touched by one of a lower caste in public, they had to be cleansed.

The *caste system*, which is now illegal, still affects many of the social interactions in the country. In the caste system, there are four rankings. These rankings separate people based on their jobs and the ranking of their parents. People whose parents are in the lowest caste are usually put in the lowest caste too. The highest ranked caste, the Brahmans, are mainly priests. They are given great respect because of the importance of religion in India. The second highest ranked caste, the Kshatriyas, are the warriors and princes. The third caste, the Vaishyas, are the merchants and farmers. The fourth and lowest ranked caste, the Shudras, are the laborers. Below the lowest caste are the Untouchables. The

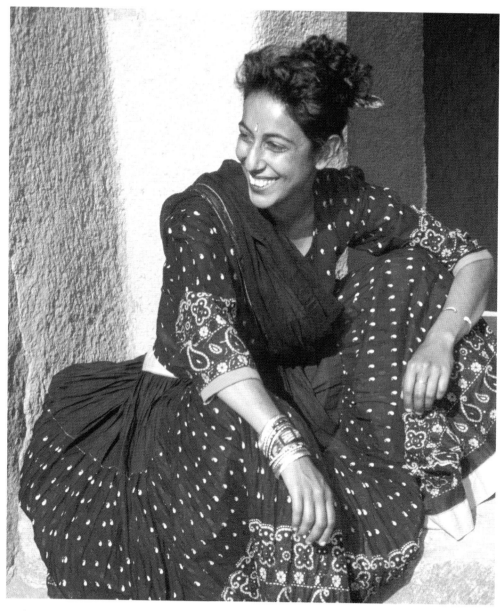

A modern woman in India may know more freedom than her grandmothers and greatgrandmothers did.

WOMEN IN THE WORLD OF INDIA

Untouchables are people whose work is considered unclean. Sewer workers and street sweepers are examples of Untouchables. The caste system is a teaching of the Hindu religion. Women are not truly recognized in the caste system, leading to prejudice against them in many social circumstances.

❀ ❀ ❀

By the mid-1800s, about three fifths of India was run by a British trading organization called the British East India Company. This group's main goal was to make money, but they did do some work to improve the country, building roads and such. In the early 1800s, they introduced Western education and legal systems. In addition, the Company tried to create social change, such as ending slavery and the caste system. It sought to improve the position of women in the family, and it outlawed suttee.

Despite these laws, a severe lack of educational opportunity limited the lives of almost all women in India. Boys were seen as more valuable than girls, and therefore, educational resources were devoted to the education of male children. In the case of poor families, the girls were often completely denied education in favor of the boys of the house. A side effect of this educational divide has been that women in India were forced to work undesirable jobs that educated men refused to fill. Because many of these jobs were considered unclean, the women that worked them were considered Untouchable. This caused further discrimination against these women, expanding the gap between them and the rest of India.

"FOR EVERY STEP THE [WOMEN'S] MOVEMENT TAKES FORWARD, THERE WILL BE A

POSSIBLE BACKLASH, A POSSIBLE REGRESSION. . . ." —URVASHI BUTALIA

# LIFE TODAY FOR WOMEN IN INDIA:
## AN OVERVIEW

In dusty, rural Rajasthan, Anita Chaudry trudges down a dirt track for nearly an hour. She is on her way to her all-girl school. She is hot, but she doesn't expect any relief when she arrives at school. There are no fans to move the air on the steamy day. When Anita arrives, she will sit on the floor to listen to the teacher. Anita's class is very large. There are only five teachers for the three hundred girls in the school.

Anita is the first girl in her farming-caste village to make it to the tenth grade. Her parents cannot read. They spend their days bent over, working the fields. Anita wants to be a doctor, but this probably will not happen. Her teachers tell her that she needs to bring her grades up ten points to even have a chance at junior college. Anita doesn't realize how far behind she is. She doesn't know that only five percent of the girls who make it to twelfth grade ever make it to college. She doesn't know about the classes that girls in the cities take to help them through the exams that they all must pass to get beyond tenth grade.

Anita's teachers have targeted her. They think she has a chance. They push her each day to study hard. They hope she will join the short list on the principal's wall. It names the dozen girls who have made it to higher study since the school opened five years earlier.

✿ ✿ ✿

India is a large country with a wide variety of languages, cultures, *ethnic groups*, religions, and lifestyles. By area, India is the seventh largest country in the world. About 45 percent of the land is used for farming. By population, it is the second largest country, with around one sixth of the world's people living in India today. India has twenty-five states. Each state has a local government of elected officials.

Under India's laws, men and women are equal. However, the reality for most women in India is quite different. The laws that protect women are typically only enforced in cities, where only a quarter of Indian women live. The other three-quarters of women live in villages or in the country. Even in cities, older members of the family still arrange most marriages. Women remain subject to male authority. The normal life pattern for an Indian woman is that she must first obey her father, then her husband, and then her son.

Although many women in India cannot read and write, some of the women do have the opportunity to go to college. They then can become professionals, working at jobs like doctors, lawyers, and architects. Most of these women live in cities, but women from rural areas do get the chance sometimes. As Anita's story shows, however, it is quite rare. Of course, a lack of education is not the only hurdle faced by women in the working world. Many people in India do not like the idea of women working. This clearly affects the chances for women to get good jobs.

Women's movements formed and grew in India many years ago. They have managed to get many new rights for Indian women. Women gained the right to vote and other legal rights at the time when India became free from Britain,

WOMEN IN THE WORLD OF INDIA

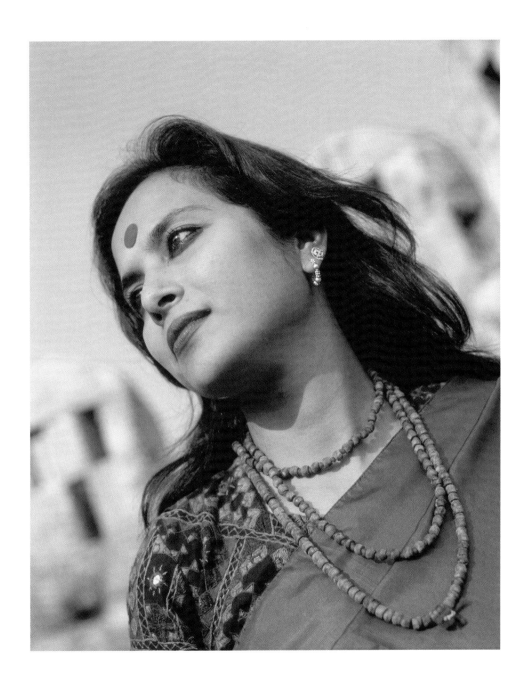

According to the Food and Agricultural Organization (FAO) of the United Nations (UN), the improvements in the education system have not closed the gap between the reading rates of men and women. In 1997, only 38 percent of women could read or write, while 66 percent of men were able to do so. The reading rates of urban Indians are also very different from rural Indians, especially for women. Sixty-four percent of urban women can read, but only 30 percent of rural women have that skill. There is a smaller, but still important, difference between urban men and rural men. Sixty percent of men in rural areas and 80 percent in urban areas can read.

in 1947. Many of the women's groups that worked for these rights are still active today. One of the groups that is busy in India today is the Self Employed Women's Association, or SEWA, which formed to help women gain economic power.

Women of the upper classes head political parties, and are very popular throughout the country, yet fewer than 10 percent of the members of the

Parliament and state legislatures are women. The presence of women in the government indicates some change is occurring. The process is slow because there is resistance to changing traditions. Even today, many companies have an unspoken rule: do not hire women. Some of the companies do not even try to deny that they are hiring only men. They say openly that they are traditional companies that don't hire women. Companies that do hire women often will not allow them to work in positions that are high ranking. Few Indian companies can honestly say they have women in management roles.

Life for women in India, especially in rural areas, is hard. A typical Hindu wife rises before the sun. She offers bread to the gods of her home, and prays.

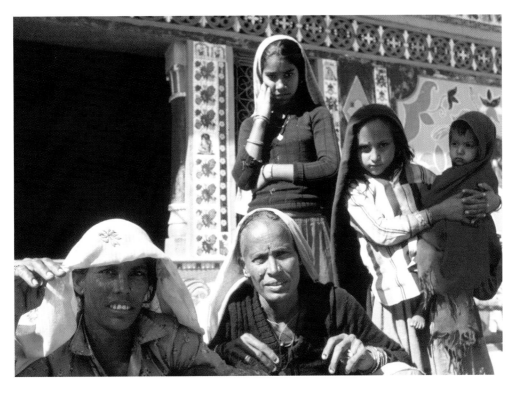

She performs rituals, such as painting the floor with flour, to protect her family. After cooking breakfast, she will start her workday. She is likely to do something like weaving baskets or cloth, raising silk worms, or working in the rice field. In the afternoon, she will come home to get water and cook another meal. She will not take her meal until her family has eaten theirs.

❧ ❧ ❧

Not all of the communication in India is spoken. Sometimes, people will use hand motions to quietly "speak" to each other. Here is a partial list of some common hand motions:

• A tug of the ear: "I'm sorry" and "I was wrong."
• Touching someone's feet: an expression of respect, usually only shown to older people.

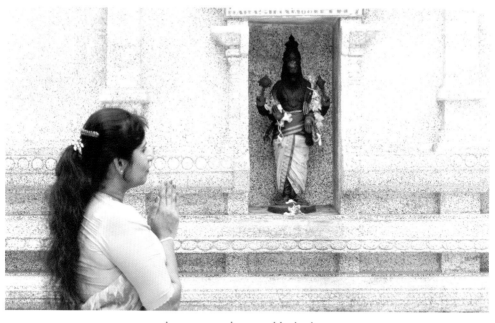

A woman worships at a Hindu altar.

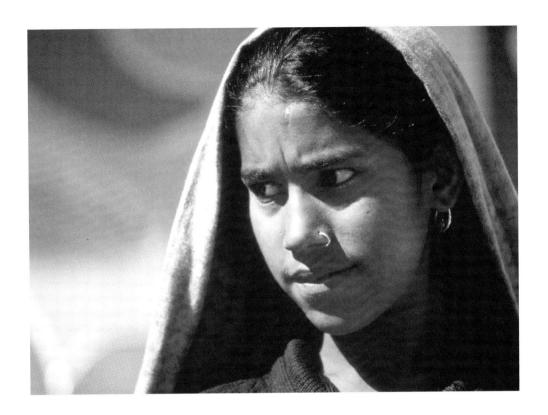

- Pressing palms of your hands together and saying "Namaste": similar to a handshake. Hindu traditions restrict the actual touching of others, so this is how Indian people shake hands.
- Waving your hand over someone's head: protects against evil spirits that may cause a person trouble later in the day.
- Lifting your pinky finger: you have to excuse yourself for personal reasons.
- Waving your thumbs at someone: a "shame on you" gesture. This is used in public to say someone did something wrong and should be sorry for it.

A great difference exists between life in the cities and life in the country or the villages in India. Women in the cities often have access to the latest technology, such as computers and the Internet, while women in the country often do not even have the electricity they would need to run such technology.

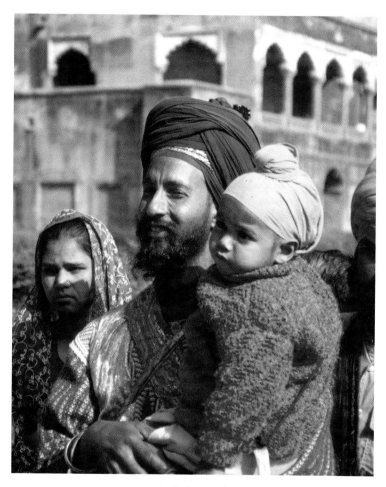

An Indian family.

WOMEN IN THE WORLD OF INDIA

According to the UN FAO, 95 percent of city homes have indoor plumbing. Compare this to rural homes, where only 15 percent have running water.

Many of the most extreme practices that were common fifty years ago have all but stopped. For example, suttee is rarely reported in modern India. Child brides were once very common, and now they are very rare. (They were outlawed in the 1950s when the legal marriage age was raised to eighteen for women and twenty-one for men.) Although such things do still happen, it is mostly in the rural areas in certain regions of the country. Only the strictest Muslim women still cover themselves from head to toe when going out in public.

In spite of the changes, India has a long way to go before men and women are treated equally. A very serious matter that is still at the cutting edge of women's issues is "bride burning" or "dowry murders." Women today continue to be killed if their husband's family is unhappy with them. This is often because the dowry is not paid as promised or the woman does not have a son. Another issue that continues to be a problem in modern India is female *infanticide*. This killing of girl babies happens startlingly often, especially in rural areas. The structure and history of Indian culture makes people want male children more than female. As a result, hundreds or maybe even thousands of girl babies are killed each year.

Prostitution is an active industry in India today. Many girls and women in urban areas and along busy shipping routes work in the sex trade. Most of the women who enter this trade do so because they are very poor or are abused at home. However, these women usually face even greater abuse from their employers and customers.

Indian society continues to change, quickly in the cities and more slowly in the countryside. Women have made many gains, but women's rights *activists* admit that they have a long way to go.

"THEY SAW BEFORE THEM THE MOTHER GODDESS, THE INCARNATE OF UNPRETENDED MERCY,

WITH A FACE READY TO OFFER HER GRACE, THE MOTHER OF THE WHOLE UNIVERSE. . . ."

—FROM THE DEVI GITA, A SACRED TEXT OF THE HINDUS

# INDIAN WOMEN IN RELIGION

It is early morning in the Indian state of Tamil Nadu. A little boy lies sleeping on his bed mat. Around his wrist is a leather string with several small cylinders attached to it. Each of the cylinders contains a special ward against illness or evil spirits. His mother made it for him.

While he sleeps, his mother rises from her mat and steps outside. She quietly sweeps the ground in front of the house. Then she washes the ground and doorstep with water. She takes a handful of white powder and carefully draws a few lines on the doorstep. These are symbols meant to protect the house from evil spirits. On the still moist soil in front of the house, she creates a pattern of white dots and draws a curving line around the dots. This is called a kolam, another symbol used to protect the family from evil. Only women draw the kolam.

After drawing the symbol, she picks up a bucket. She walks several miles to the public tap and then totes the water back to her house. When she returns, she begins the daily process of baking bread. By now, the men have awoken and

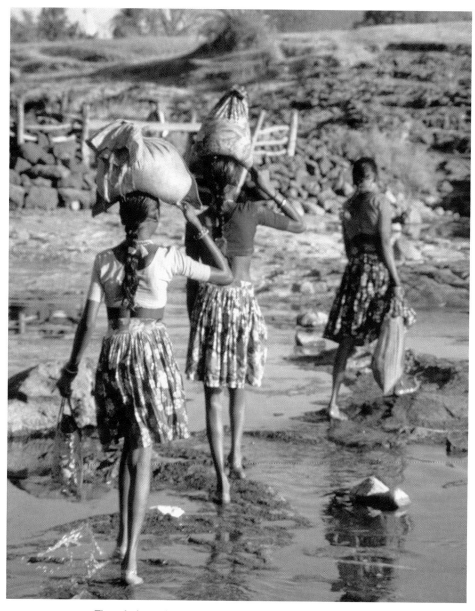

These Indian girls carry their groceries home from the market.

WOMEN IN THE WORLD OF INDIA

want their breakfast. She cooks this for them while the dough rises for the bread.

At the end of breakfast, the men leave the house to go to work. After the bread is cooked, she goes out to thresh soybeans for future meals. She then goes to the market to buy food for lunch, the largest meal of the day. The meal must be prepared fresh each day, since her family does not have a refrigerator in which to keep leftovers.

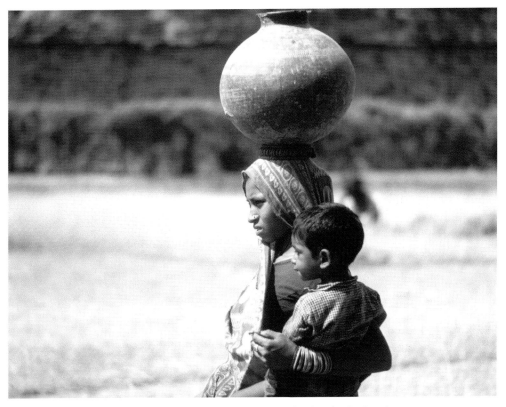

Indian women are responsible for caring for their families' needs.

While waiting for lunch to cook, she offers her daily prayers over special oil lamps. Today, she also makes a special meal to offer to the gods. She can make this only because she is a woman. After making the offering, she cleans the house and makes the family supper. When the men return at the end of the day, she serves them supper. She and the other women of the house care for the young, bathing them and putting them to bed. Since she is the newest wife, she is the last to sleep in her household. Tomorrow she will again be the first to rise in the morning to begin the work once again.

This is an example of a typical daily routine for the women of India. Some women are expected to work outside the home in addition to the daily task of

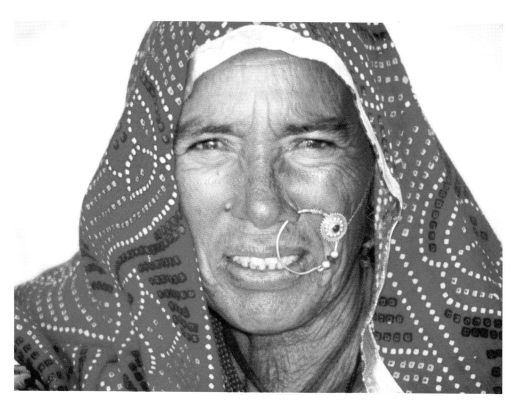

Hinduism is one of the world's most complex religions, with many gods and goddesses and ways of worshipping. It was developed over thousands of years, blending a variety of religions, and it has several sacred texts, including the Vedas and Upanishads. Hindus believe that the universe is made up of an all-powerful spiritual force called brahman. The many gods and goddesses give concrete form to brahman, a concept that most people cannot truly grasp. The ultimate goal of life is to achieve moksha, or union with brahman. Moksha is achieved by putting aside selfish desires. Hindus believe that most people cannot achieve moksha in one lifetime. As a result, souls are reborn, or reincarnated, in another body. Hindus move towards moksha by obeying the law of karma, or the rule that all actions in one life affect fate in the next. Bad deeds cause bad karma, which causes rebirth into an unhappy life. This cycle is like a wheel of fate. To escape this wheel, Hindus do their religious and moral duties, or dharma. Dharma is determined by age, class, and gender. The concepts of karma and dharma support the caste system.

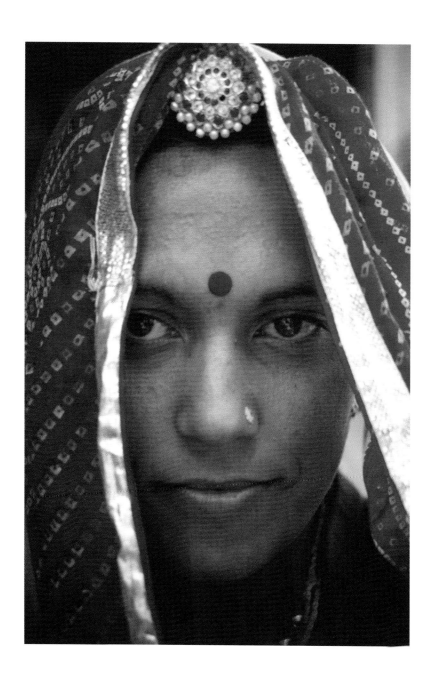

WOMEN IN THE WORLD OF INDIA

housekeeping. Often these women are forced to take the very young children out to the fields with them because no daycare is available. Women are often overworked and under-appreciated. They are rarely paid as much money as men, even though men do very few of the daily tasks and often work less physically demanding jobs.

And yet India is a highly spiritual country. It has many different religions, each with a different set of principles and traditions. Most Indians are Hindu, but other religions have helped to shape the culture in present day India.

The holy dot or bindi is the red makeup worn by young Hindu girls and women on their forehead. The term comes from "bindu," the **Sanskrit** word for a point. It is usually a red dot made with vermilion, a type of dye made by grinding minerals to a fine powder. Considered a blessed symbol of Parvati, a Hindu goddess, the bindi signifies female energy. Indians believe it protects women and their husbands. The bindi was traditionally a marriage symbol, but is now worn as decoration. Unmarried women of other religions may also wear it.

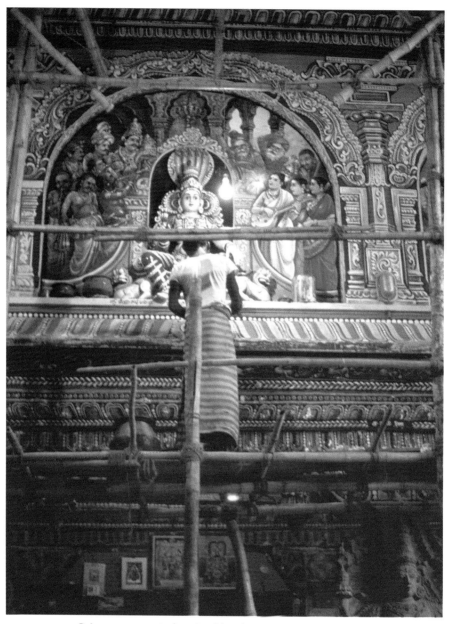

Religious art reveals the role of female power in the Hindu faith.

WOMEN IN THE WORLD OF INDIA

Many of the differences between men and women in India can be traced directly to the religious traditions of the country. The ideas of caste and gender ranking have deep roots in the ancient history of the nation. The teachings of Hinduism suggest and strengthen the caste system, long thought to be one of the main factors in the poor status of women. The standing of women within the caste system was often below that of the lowest caste, the Shudras. Although the caste system was outlawed, it is still in use in many areas of India. It continues to make the struggle for the rights of Indian women harder.

Another factor in the role of women in India involves the concept of *shakti*. In the Hindu faith, shakti is defined as female power or energy, the source of fertility and creativity. In order for this power to be useful, it must be properly focused. Shakti is formless and dangerous unless it is guided by a man. This is one more way that Hinduism separates males from females. Masculinity and femininity are often seen as opposite forces. According to Hindu teaching, shakti is best controlled through marriage. A woman's sexuality is transferred to her husband when she marries. The Brahman, or priest caste, have used this idea to limit the freedom of women in India.

Suttee is another example of the influence of religion on the behavior of Indian women. According to the Hindu faith, a woman who throws herself onto the funeral pyre of her husband will be forever blessed. This tradition is rarely practiced anymore, due in large part to the efforts of Mahatma Gandhi. Only two incidents of suttee have officially been reported in the last twenty years. While the actual practice has declined, the mindset behind it remains. Women can also get this blessed status by becoming a *satimata*, or living goddess. Women do this by becoming "perfect wives." They devote themselves completely to their husbands by doing religious rituals, housework, and being sexually pure. Great self-sacrifice, duty, and honor give a woman virtue she uses to protect her family. If she can do this perfectly, she becomes a living goddess.

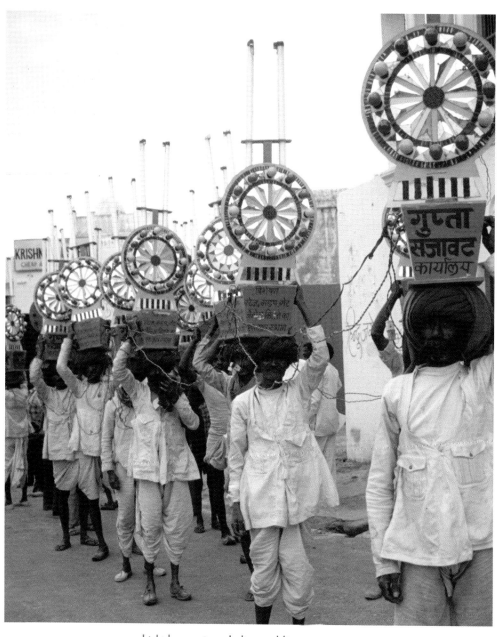

Light bearers in an Indian wedding procession.

WOMEN IN THE WORLD OF INDIA

According to the Food and Agricultural Organization of the United Nations, 83 percent of Indians are Hindus, 11 percent Muslims, and the remaining six percent is divided between Christians, Sikhs, Zoroastrians, Buddhists, Jains, and Jews.

Other religions have had their own effect on the status of women in India today. Some readings of Islamic religion, for example, require women to practice the tradition of purdah (see chapter 1). Not doing this can cause serious problems. Strong believers in Islam feel that purdah actually frees the woman by allowing men to see her for her mind, goodness, and personality. Critics of the practice believe that forcing women to wear such clothing has strong effects on their self-esteem and confidence in public, which spills over into the home. The combination of the Islamic tradition of modesty with the traditional Indian modesty strengthened this practice during periods of Indian history. In modern India, however, purdah is mostly observed only by very strict Muslims.

Women of India are seen as central figures in the family, both honored and mistreated. The Hindu religion calls for the worship of women, yet it denies them privileges that are considered basic human rights in many parts of the world.

"THE GREAT INDIAN DOWRY CUSTOM CONTINUES TO RULE SOCIETY REGARDLESS OF REFORMS AND REGULATIONS.

A STRONG AWARENESS THAT MARRIAGE IS NOT A RETAIL SYSTEM WILL BE A STEP IN THE RIGHT DIRECTION."

—INDRA CHOPRA

# WOMEN IN INDIAN FAMILIES

Priya had just graduated from college when her father died of kidney failure. In accordance with Indian custom, which dictates that daughters marry soon after their fathers pass away, Priya's mother quickly began to seek a husband for her daughter. She did not ask Priya's help in choosing her future spouse. Instead, she contacted a friend of Priya's father to discuss the possibility of a marriage between Priya and the son of that family. Without the couple ever meeting, a marriage proposal was made and accepted.

Priya's mother showed her a small photograph of her fiancé. She did not ask Priya if she wanted to marry him, and Priya did not expect to have any say in the matter. Priya's mother merely handed her the photograph and left. Priya knew she would be a burden on her mother if she did not marry, so she accepted her mother's choice.

One week later, Priya met her husband-to-be at an evening tea at her aunt's house. He was more handsome than he had looked in the photograph. She was pleased at how nicely he spoke to her and that he had three sisters. Although

Priya loved her three brothers, she had always longed for a sister. She hoped they would be happy together.

❀ ❀ ❀

In India, most marriages are arranged by family elders. Parents or aunts choose mates for their children based on reputation and economic status of the family. Traditionally, children were engaged and married at very early ages, sometimes at six or younger. However, the marriage of children is illegal in modern India. Such things only occur rarely, and then usually only in rural areas. Although some couples still do not meet until their wedding day, many couples are allowed to date in the period between their engagement and their wedding. Sometimes women are even allowed to refuse to marry the chosen man, though that is still frowned upon in Indian society.

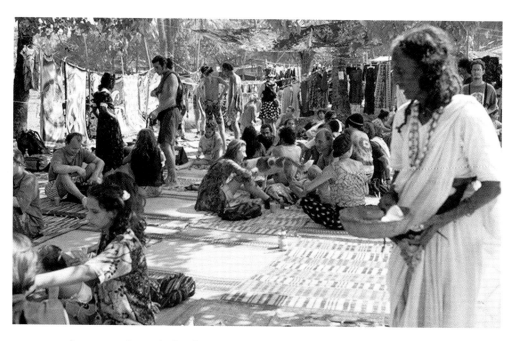

A woman without a husband may have to resort to begging as this woman is doing.

WOMEN IN THE WORLD OF INDIA

## TWO INDIAN "PERSONAL ADS"

Hindu parents invite correspondence for their handsome, sophisticated son, 231 lbs, 5'11", pediatrician. Send biodata and photograph.

26 year old, handsome, tall, caring electrical engineer seeks marital correspondence from educated girl. Caste no bar. Biodata/photo to Dr. M.B.

Once the couple is married, the dowry would traditionally have been due. The dowry was set by the man and was paid in property and money. As of 1995, demanding a dowry is illegal. However, in practice, dowries are still the norm. The bride's family usually pays the dowry because Indian women have little money or property to give. Many problems come from a new bride not being able to pay the dowry demands of her new husband.

As India modernizes, its marriage customs have begun to change. Especially in urban India, more people are using classified ads, either in newspapers or on the Internet, to find spouses. Sometimes family elders will locate a spouse using these resources. Other times the man or woman themselves will advertise and choose the spouse. The dowry system is weakening. Recently, some new brides

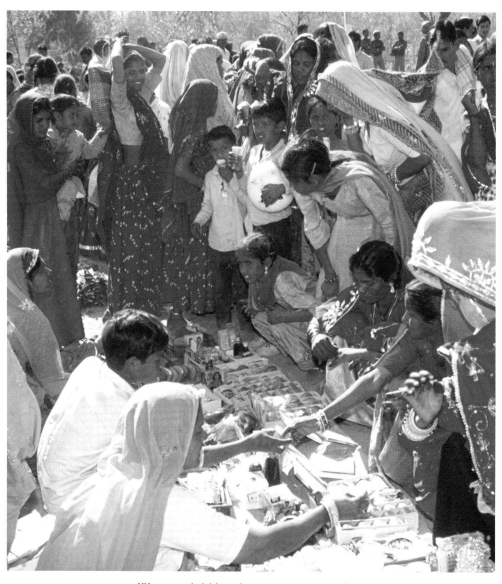

Women and children shop at an open-air market.

Fords Middle School Library
Fanning Street
Fords. NJ 08863

have refused the dowry demands of their husbands and were not punished for it. Tales of these women and their brave refusals have become instant legends in India. Mostly, the changes start in the urban areas and slowly spread across the rest of the country. The exposure of city people to travelers from other countries has affected the Indian culture in the cities.

In India, most people speak a musical language called Hindi. Here are some of the words that an Indian would use when talking about her family:

mother: **mata** (mah-TAAH)

father: **pita** (pi-TAAH)

sister: **bahan** (BE-ha-nh)

brother: **bahai** (BHAA-ee)

daughter: **beti** (BAE-teeh)

son: **beta** (bae-TAH)

aunt: **chachi** (CHAH-cheeh)

uncle: **chacha** (CHAH-chah)

grandmother: **dadi** (dah-DEEH)

grandfather: **dada** (dah-DAH)

Still, the hard life of women in India is well known and acknowledged around the world. Indian parents sometimes say that they give extra love to their daughters in order to make up for the tough life they will have after they get married and move in with their husbands' families. Many Indian wives suffer from depression. They are poorly educated and forced to marry men they do not know. Some men are very jealous and do not allow their wives to do anything outside the house. Many Indian women are abused, both physically and mentally. Often, Indian women do not have true friendships with other women

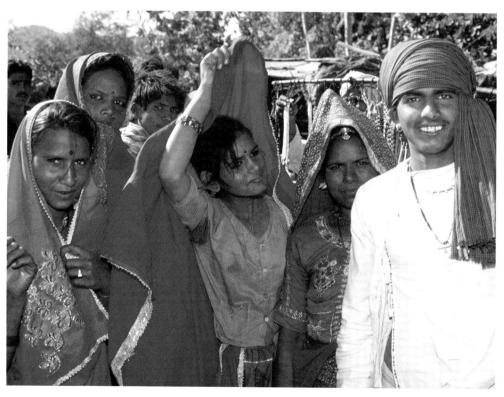

A young man accompanies his mother and sisters on an outing.

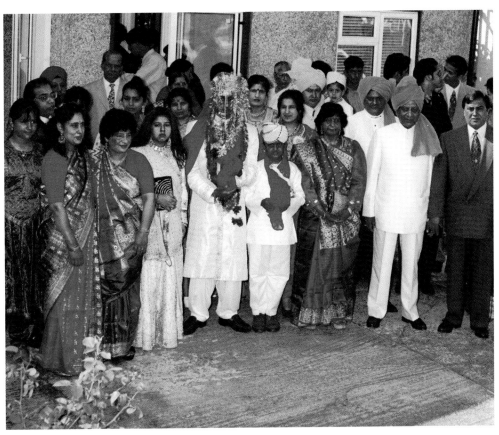

An Indian wedding.

because of the restrictions they face. Imagine trying to begin or continue a friendship without being allowed to leave your home.

An Indian woman's role starts as a daughter, and then shifts to a wife and daughter-in-law. Before she is married, she lives with her parents. When she is in her parents' village, she has much greater freedom of movement. Once she marries, she moves into her husband's family home, usually with his parents, his

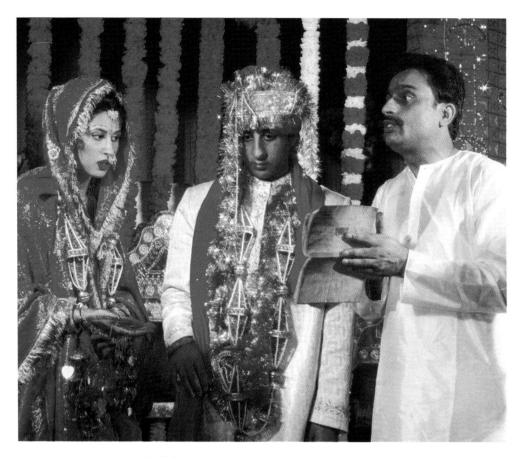

An Indian bride and grooom with a religious official.

unmarried sisters, his brothers and their wives, and even his grandparents if they are still alive. She becomes more restricted in her in-laws village. In her early years of marriage, she will have more duties and responsibilities and less freedom. When she has children and they marry, she will merit more respect and will have more freedom as the mother-in-law.

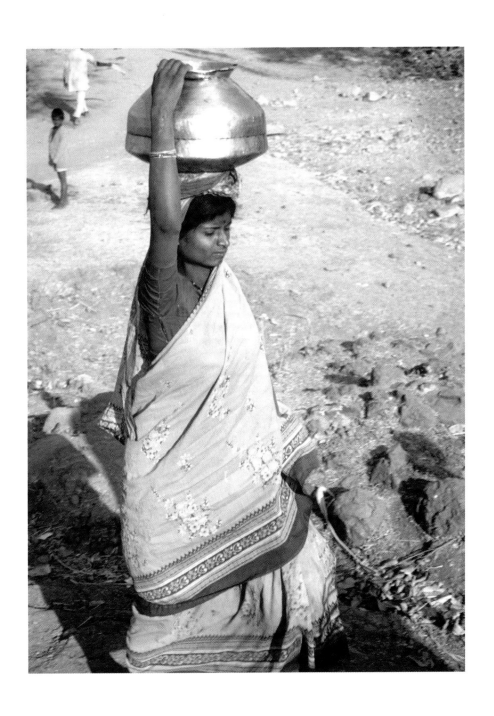

The duties of a daughter vary depending on where the family lives. For families that live in rural areas, daughters sometimes work in the fields along with their mothers. In cities, daughters are usually expected to clean and cook. The law does not allow children to work, and the law is enforced in cities. City children have schools to attend, so they spend time getting educated. Most children in rural areas receive very little education. Almost all of the education they do get is from their mothers and older brothers and sisters. Some rural areas have small school buildings that the children can attend, but most children who are allowed to go to school outside the home are boys. School in India costs the family money, so boys of poorer families go to school while girls stay home and work. Girls are expected to help clean the home and get water for the family to drink.

When a woman marries, she is taken into the home of her husband. Often, his entire family lives there. The new wife is required to care for the children in the home. She must cook. She must clean. She loses all rank and has to start from the bottom in her new home. Her husband's mother determines what her tasks will be. The expectation of the family she now lives with is that she will begin to have children as soon as possible. She can gain status in her new home only by having male children. Until then, she has almost no rights in the home. She is often treated very poorly and sometimes is forced to work as much as twenty hours each day.

After a woman has children, she begins to gain power in the home. Male children give an Indian woman standing with her new family. She gains respect and more freedom. A woman who has ten healthy sons and no daughters is sometimes considered touched by the gods. She must have done something right in a past life to have been so blessed. No wonder then that the desire for male children is very strong. Women are under constant pressure to produce healthy boys to pass on the family name.

As a woman grows older, she grows in power in her home. When her sons marry, she finds herself above the new wives in the ranking. She assigns them their daily work, and she can control if and when the younger women leave the home. The oldest woman in the home even has some influence in the decisions that the men make. There are many stories of girls being allowed to attend school or college against the wishes of their fathers after a discussion with the oldest woman of the home.

"[A] CASUAL VISITOR TO ANY INDIAN CITY . . . WILL SEE HUNDREDS OF WOMEN, YOUNG AND OLD, WORKING IN ALL KINDS OF PROFESSIONS:

DOCTORS, NURSES, TEACHERS, ENGINEERS, SCIENTISTS . . . AND YET NEWSPAPERS IN INDIA ARE FULL OF VIOLENT INCIDENTS AGAINST WOMEN." —URVASHI BUTALIA

# WOMEN IN THE WORKING WORLD

In the small town of Karnal, in northern India, the people are in shock. News has just come to them of a terrible tragedy involving one of their favored daughters: Kalpana Chawla. Kalpana was among the seven astronauts killed when the space shuttle Columbia broke up over Texas on August 26, 2003. This was not the first time news of Kalpana had shocked the town of Karnal. More than twenty years before the tragic shuttle accident, Kalpana left Karnal.

This may not seem shocking to some, but to the people of India, it was. Indian women did not leave their hometowns for college. Kalpana was, like all Indian women, expected to marry young, have children, and follow a traditional Indian lifestyle.

Kalpana had another plan. She attended college at Punjab University, upsetting her father and uncles, who fought to try to keep her in Karnal. "Only because I was a girl, people gave a hard time to my mother because she sent me to school in another town," Chawla said in a 1998 interview with *News-India Times*. "How would you feel if people don't approve of what you are doing or your mother is doing for you?"

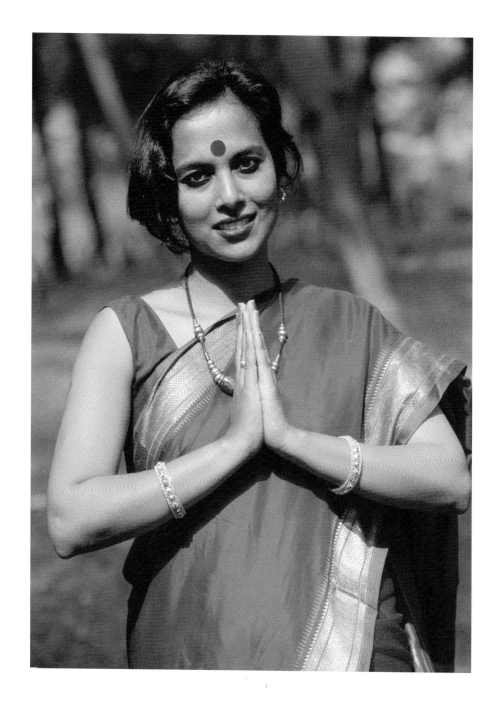

WOMEN IN THE WORLD OF INDIA

After completing a degree at Punjab, she moved to the United States and attended college. She eventually earned a Ph.D. in Aerospace Engineering. She married an American man and had no children, a fact that was not lost on the women of Karnal. Kalpana was from a culture where arranged marriages were normal, and many children were expected.

Kalpana was accepted into NASA (the United States' National Aeronautics and Space Administration) in 1994. She worked hard to achieve her lofty goal: to fly on a NASA shuttle mission. In 1997, Kalpana got her wish as she became the first Indian woman to ever orbit the Earth, aboard the NASA shuttle Columbia. She instantly became a hero in Karnal. She was a symbol to all the women of her hometown that there were options for Indian women.

Brightly colored saris.

Kalpana became a hero for many Indian young women like this one.

WOMEN IN THE WORLD OF INDIA

Kalpana Chawla was truly a trailblazing Indian woman. She broke from tradition in many ways and did things no Indian woman had ever done. Not only did she become a highly educated and successful scientist and astronaut, she became one of the few people who have been to space on a NASA shuttle! Her

For a woman like this one who has worked all her life as a farm laborer, Kalpana Chawla stands out as an example of what is possible.

legacy was not that she bore many healthy boys, nor that she worked night and day to keep her husband happy. Instead, she worked toward her own goals—and achieved them.

The women of India face special challenges on a daily basis. They are expected to shoulder most of the burden around the home. Their daily tasks are enough work that they might be treated as a full-time job in another country. Things that can be done quickly in the United States take much longer for Indian women, since many do not have running water or electricity.

Some Indian women, however, are forced to find jobs in addition to their housework in order to help make ends meet. Many Indian families are very poor, so women have to work in order to support their families. Across India, many families survive on less than $1 (U.S. funds) each day.

### SARIS AND SUITS

Traditional dress for women in India includes the sari, a dress made by wrapping the body in colorful cloth. Most Indian women continue to wear saris, though some women who work in big cities now wear business suits. Some young women in cities even wear the jeans and T-shirts they see on foreign TV and the Internet.

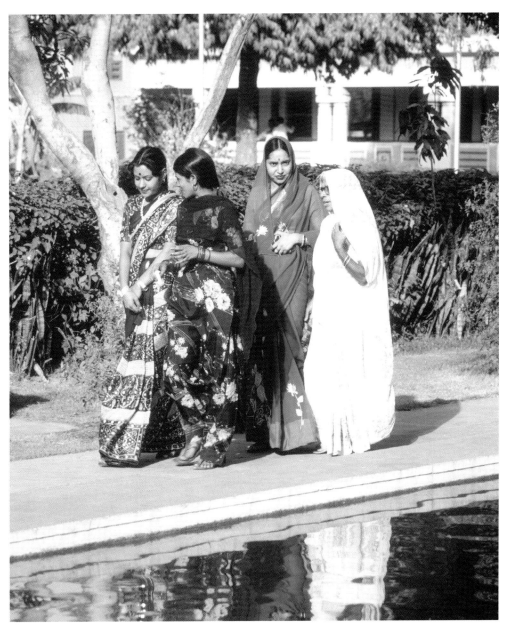

Women dressed in saris.

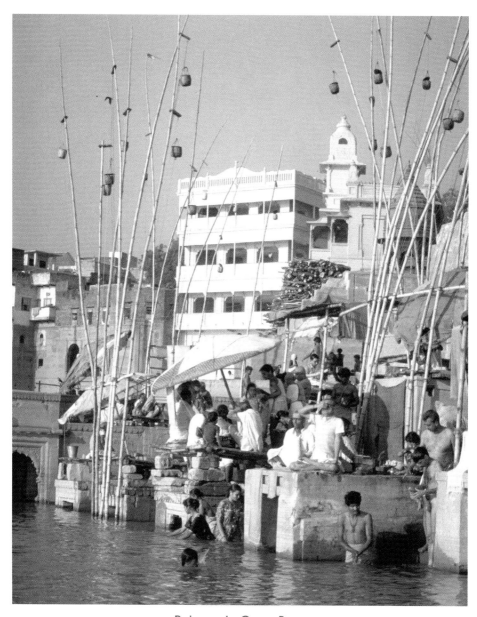

Bathing in the Ganges River.

WOMEN IN THE WORLD OF INDIA

Bombay, a large city in India, has a section known as Bollywood. This is where Indian filmmakers create movies and television shows. In fact, more films were produced in Bollywood in 2002 than in Hollywood. According to box office receipts, Bollywood films sold one million more tickets than Hollywood films.

Most of these films use Indian actors and actresses and are full of Indian customs. The majority of the films show the woman as a housewife. Bollywood films usually ignore the gains women have made in the educated professions of India. The young and attractive women cast in the films settle down to a happy married life by the end of each film. The role of women in the films reflects the traditions of the country.

The culture of India makes finding and keeping a job hard for Indian women. As a general rule, Indian society is very structured. The caste system, though outlawed, still affects almost every part of daily life in much of India. Nearly everyone is ranked by caste. These rankings alone can keep someone from getting a job, even if they are the best person for the job. Another Indian tradition that affects women is purdah. Women who practice purdah have to cover their whole bodies to separate them from men. This could certainly affect their ability to do certain tasks. Most younger Indian women do not observe purdah, a trend that makes it easier for working women.

Traditionally, women's roles have confined them to the home. As the years have passed, women have become much more present in workplaces. Most of the jobs available for women in India are the ones that men do not want, often dirty or heavy physical labor. Women work these jobs because they know they must. The women of India do their duty. They work very hard for their families. These women have always put their families first. Hundreds of years of tradition are hard to change.

In and around the cities of India, the hold of tradition is loosening due to the impact of *globalization*. Women in urban areas are exposed to more Western culture, and this is an engine for change in the cities. The women of urban areas have more opportunities. However, most of India is rural. The people of these areas are slower to accept changes to their lives. Still, the times are changing, and the women of India know more freedom than they did in the past.

In the 1990s, India had one the highest number of international beauty pageant winners, while having one of the lowest rates of female *literacy* of any country in the world. At the same time, India had one of the highest popula-

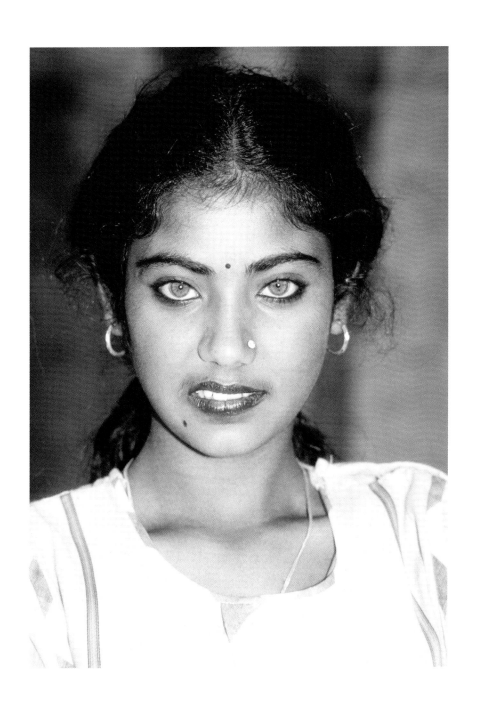

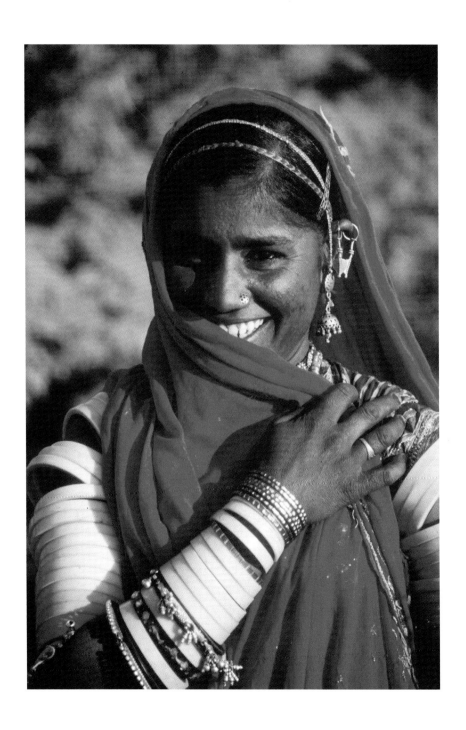

tions of female doctors, lawyers, scientists, and professors of any country in the world.

The women of India are not educated on an equal level with men. The jobs they work show this. Women of the cities are more educated than women of the country. Women are supposed to be protected by laws, but laws are poorly enforced in the rural regions of the country.

The roles of Indian women outside the family are often determined by where they live. Women of the cities, have more work opportunities. Rural women often take work in the fields, planting and picking crops. Indian culture places stresses on those women who do work. Even though they have to work to provide for the family, they are expected by tradition to remain home and care for the home and children. Many men view the concept of Indian women working as dangerous to families. In spite of these challenges, however, Indian women are working today.

Typically, the women in urban areas have chances in those jobs that men see as "women's work." These may include jobs like secretaries, clerks, school teachers, and nurses. Women are expected not to compete with the men for jobs in the higher paying and more prestigious fields. India does not have many factories, so there are fewer low-skill jobs available. As a result, most of the jobs available to women in the cities are truly undesirable, such as street sweeping or garbage picking. Although the cultural restrictions that women face are changing, there is a genuine shortage of jobs, a factor that contributes to the unemployment of women.

Most Indian people work in farming. There are millions of women employed in the fields. In India, the farming industry is broken down into two types of jobs: cultivators and laborers. The cultivators are the higher paid, more skilled workers that plant and care for crops. The laborers are the physical laborers who harvest crops in the fields. There are nearly as many female cultivators as there are men. However, the women make much less money than the

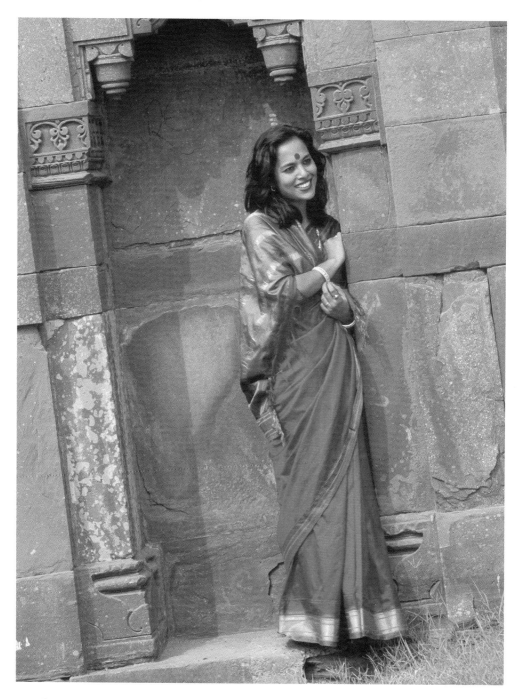

WOMEN IN THE WORLD OF INDIA

men. Men typically earn 35 to 60 percent more than women for similar work. There are about twice as many women as men in the laborer category, and the pay for laborers is much less than for cultivators. Female laborers make even less. Some do not get paid at all. The work of the laborer is very hard physical work that involves heavy lifting and long days.

Although Indian women have made many gains in the working world, women still do not have nearly the opportunities that men have. They make less money and work less appealing jobs. This trend will almost certainly continue in many parts of India for many years to come.

"I SUPPOSE LEADERSHIP AT ONE TIME MEANT MUSCLES; BUT TODAY

IT MEANS GETTING ALONG WITH PEOPLE." —INDIRA GANDHI

# INDIA'S DIVAS: OUTSTANDING PLAYERS IN THE DRAMA OF LIFE

Throughout the course of its history, India has been graced by a number of outstanding women. These ladies, *divas* in the modern sense of the word, have done and continue to do much to alter the course of this diverse nation's history.

## MADAME BHKAJI CAMA
### 1861–1936

"This flag is of Indian Independence. Behold it is born! It has been made sacred by the blood of young Indians who sacrificed their lives. I call upon you, gentle men, to rise and salute this flag of Indian Independence. In the name of this flag I appeal to lovers of freedom all over the world to cooperate with this flag."

These words were spoken with passion by Madame Bhikaji Cama. She was a small, middle-aged Indian woman who unfolded a new flag in front of the

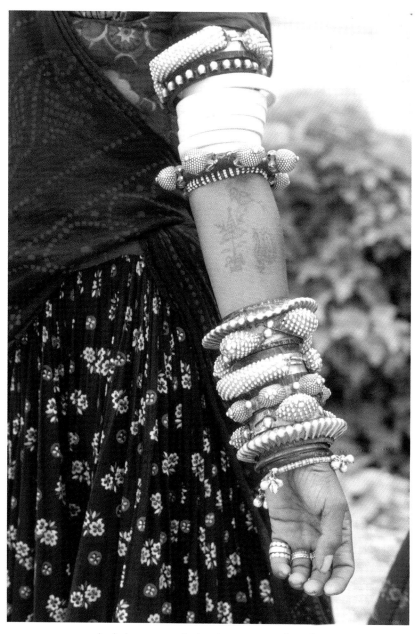

An Indian woman displays her tattoos and jewelry.

WOMEN IN THE WORLD OF INDIA

International Socialist Conference in Stuttgart, Germany, in 1907. India would not be free from Britain for forty more years. At that time, people who talked about independence could be punished. Still, Madame Cama spoke loudly and clearly. She faced the room full of a thousand men from many countries in her colorful Indian dress.

Zoroastrianism is a religion that came to India more than a thousand years ago. It was originally practiced by the people who lived in the area that is now Iran before they became Muslims. A person who practices Zoroastrianism is called a Parsi. They believe that there is one Supreme God. Good and evil battle for control of the universe. Parsis believe that fire, water, and earth are basic elements that should be kept pure. Parsis do not dispose of their dead by burying, cremating them, or placing them in water, since this would allow death to touch fire, earth or water. Instead, the dead are placed on "towers of silence" to be eaten by birds.

Madame Cama was born in 1861 to wealthy Parsi parents. She received a good English education, but was quite young when she got interested in nationalism. She got married, but ended her marriage because of political differences and became very involved in a new Indian *nationalism* movement. This movement wanted to free the country from British rule. When the *plague* struck India, she joined a group caring for the ill. She caught the disease and it made her very weak. She moved to London in 1902 to recover and lived there until threats to her life forced her to leave for Paris.

The flag she waved in Germany had green, saffron (a yellow-orange color), and red stripes. The green represented boldness. The saffron was for victory. The red meant strength.

The British were afraid that she would encourage people to riot against them. They decided not to let her back into the country. She died in 1936, after letting many people across the world know about the fight for Indian independence.

## INDIRA GANDHI
### 1917–1984

Most countries, including the United States, have never had a female head of state. India elected a female prime minister as long ago as the 1960s.

India became free from Britain in 1947. Its first leader, Jawaharlal Nehru, ruled as prime minister until he died of a stroke in 1964. The next prime minister died soon after taking office. After his death, Nehru's daughter, Indira Gandhi, was selected to replace him.

Indira Gandhi was born in 1917 in Allahabad, India. When she was only two years old, her parents were visited by Mohandas Gandhi, the leader of the Indian freedom movement. He convinced them to join the cause. They spent the next thirty years working in the Indian National Congress. The Congress was a group that wanted to return the rule of India to Indians.

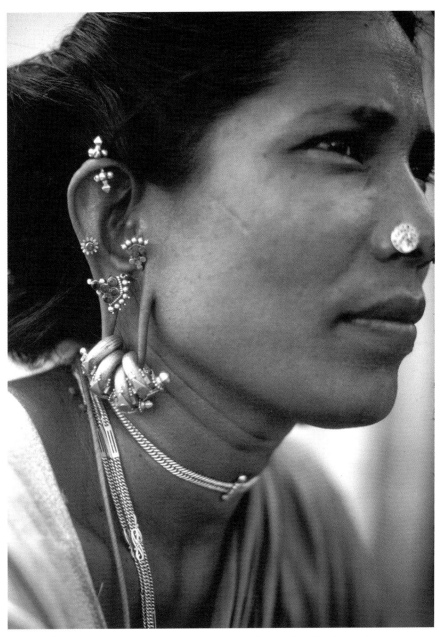

This woman, among many others, benefitted from Indira Gandhi's policies.

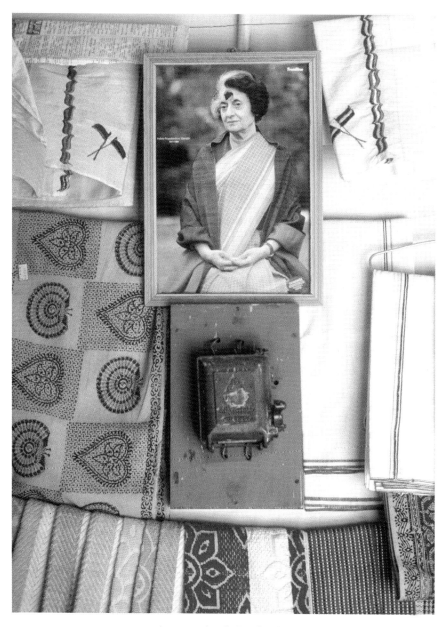

A memorial to Indira Gandhi.

WOMEN IN THE WORLD OF INDIA

When Indira was twelve years old, she was upset by the fact that she was too young to join the Congress. She decided to organize her own version for young people. She called it the "Monkey Brigade." It quickly grew to have more than a thousand children as members. Indira and the other children carried messages to members of the freedom movement. The children would warn them that they were about to be arrested by British soldiers. By the time the soldiers arrived, the houses were empty. The soldiers would pay no attention to the children running away.

Indira named her "Monkey Brigade" after an army of monkeys in an old Indian folk tale called the **Ramayana**. In the story, a prince, Rama, rescues his wife, the beautiful Sita, with the help of an army of monkeys. After rescuing her, Rama is concerned that she was not faithful to him during the time she was kidnapped. She has to walk through fire in order to prove to her husband that she did not betray him. She comes out of the fire unhurt, and he accepts her as his wife again.

Indira's parents spent much of her childhood in and out of jail as a result of their political activities. Indira spent most of her childhood being cared for by her grandmother.

Indira married in her mid-twenties. Although she was an upper-caste Hindu, she married a much poorer man of a different religion. Her father and the public criticized her for this. Soon after her marriage, she was jailed for nine months for her political activities.

Indira's father, Nehru, became prime minister after India finally became independent from Britain. She, her husband, and their two sons moved into the country's official residence with her father. She spent much of her time helping her father with political matters and acted as the "First Lady" of India, since her mother had died years before. Eventually, she became a politician in her own right. She was elected president of the Congress Party in 1959.

When her father passed away in 1964, Indira was not seriously considered to replace him. Instead, Lal Shastri was chosen, and Indira accepted a job in his government. She made a point of working with and talking to Indian people from all walks of life. When Shastri died two years later, Indira was elected as prime minister. When the voting was over, the representative of her party came outside and shouted, "It's a girl!"

One of the reasons a country like India was able to elect a woman to its highest office has to do with the way that prime ministers are chosen. In the United States, the president is chosen in an election by all adult citizens. India's prime minister is chosen differently. India has a ruling body like the U.S. Congress, called Parliament. This ruling body, rather than the people, chooses the prime minister. This allows people for whom average Indians might not vote to get elected. Experts believe that Indira could not have gotten elected if India's system was like the United States'.

India was a troubled country at the time Indira became prime minister. She was the third leader in three short years, and the country had just finished two

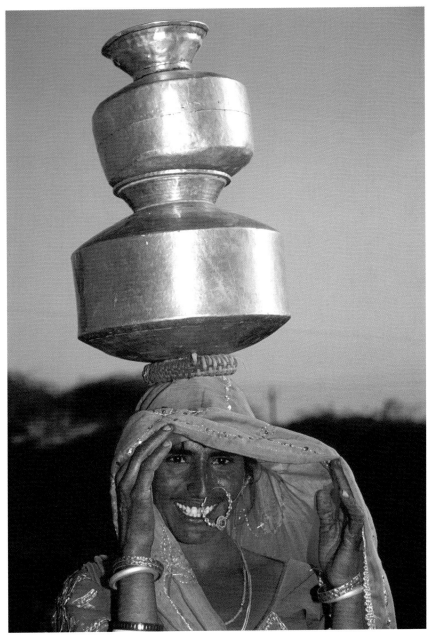

Indira Gandhi made a point of getting to know all different kinds of people, including women.

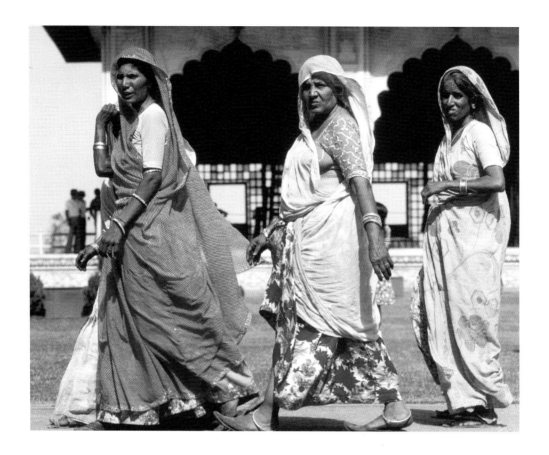

wars, one with China and one with Pakistan. Some parts of the country were struggling with famine because the *monsoons* had not come the previous two years. There were many struggles during Indira's rule.

In 1975, the high court of India ruled that she had broken election laws in her last run for prime minister. Rather than step down, Indira declared a state of emergency and put her enemies in jail. Many people believe that Indira's actions did great damage to democracy in India.

WOMEN IN THE WORLD OF INDIA

She was briefly replaced as prime minister in 1977 but was reelected only a year later for her fourth term. This was a very stormy time. In the 1980s, several ethnic groups tried to break away from India. One of these ethnic groups was called the Sikhs. This religion rejects the caste system and the idol worship that is so important to Hindus.

Indira sent the Indian army to fight with Sikh freedom fighters in 1984. More than six hundred people were killed in the conflict. Only a few months later, Indira was assassinated by two of her own security guards, followers of the Sikh religion.

Many people disagree about whether Indira Gandhi was a great or even a good ruler of India. However, she certainly has provided a role model for Indian girls who want to change their country.

## ELA BHATT
## 1933–PRESENT

Ela Bhatt has been toiling for the poor working women of India for decades. Trained as a lawyer and social worker, Ela became aware of the working conditions of self-employed women in her country while working for a labor union in the 1960s. These women included stitchers, weavers, garbage pickers, and sellers of fruit, vegetables, fish, and firewood. Most of these women had to pay very high rent to sell their goods. They were very often harassed by employers, government officials, and money-lenders. Almost all these women lived in the slums and could not read. They owed money to the lenders and had to bring their children to work with them or starve.

These women inspired Ela to found an organization in 1972 to help them. It is called the Self-Employed Women's Association (SEWA). After only three years, SEWA had more than 7,000 members and was a registered trade union. According to its 2002 Annual Report, its membership had swelled to nearly 700,000 thirty years later. Most of its members today live in rural areas.

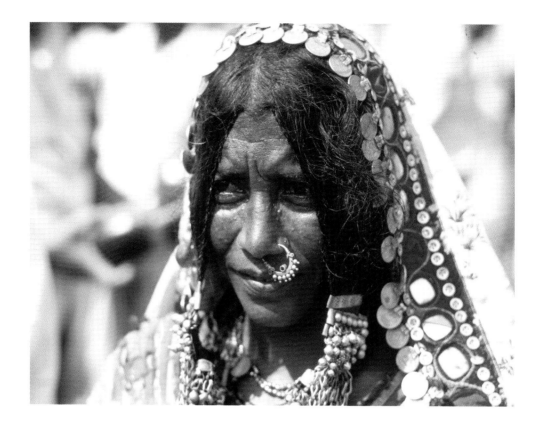

SEWA's main goal is to organize its members for "full employment" and "self-reliance." The women want to stay healthy, find childcare and shelter, and increase their income and their leadership and employment skills.

According to SEWA's 2002 Annual Report, there are four kinds of women workers among its members:

**Small producers:** women who invest their own labor and money into businesses, including workers, women who do embroidery, cattle rearers, and others

WOMEN IN THE WORLD OF INDIA

**Home-based workers:** weavers, potters, cigarette rollers, tailors, dry food makers, and those that work from their homes

**Vendors or traders:** women who buy goods like fish, vegetables, or clothes from wholesalers in other parts of the city

**Laborers and service providers:** women who provide labor services, like farm workers, construction workers, washerwomen, cooks and other service workers

Ela also helped to create Women's World Banking, where women can start a savings account with a few *rupees*, Indian money worth less than a penny. They can also take out small loans at fair rates.

She has been active in Indian politics as well. A member of India's Parliament for three years in the 1980s, she also served on India's Planning Commission for several years.

Ela continues to live a simple life with her family in India today. She also continues to speak out and work on behalf of the women of India.

## ARUNDHATI ROY
### 1961–PRESENT

Arundhati Roy is an Indian writer and *peace activist* who has lived a varied and unusual life. She was born in 1961 in eastern India to a Christian mother and a Hindu father and spent her childhood in Kerala, a state along the coast in southwestern India. At age sixteen, she left home for the capital of India, Delhi, where she lived a very non-traditional lifestyle for a while, selling empty bottles in a squatter's camp. She wanted to make sense of the poverty of her country.

Eventually, she was trained as an architect at the Delhi School of Architecture, but she quit working as an architect to become a beachcomber.

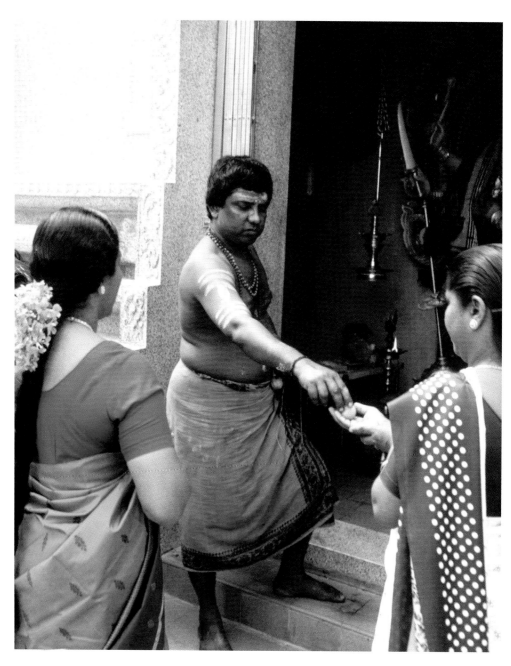

WOMEN IN THE WORLD OF INDIA

Arundhati then met her husband, Pradeep Krishen, a movie director. She acted in an award-winning film and wrote several screenplays.

> They were nearly born on a bus, Estha and Rahel. The car in which Babu, their father, was taking Ammu, their mother, to hospital in Shillong to have them, broke down on the winding tea-estate road in Assam. They abandoned the car and flagged down a crowded State Transport bus. With the queer compassion of the very poor for the comparatively well off, or perhaps only because they saw how hugely pregnant Ammu was, seated passengers made room for the couple, and for the rest of the journey Estha and Rahel's father had to hold their mother's stomach (with them in it) to prevent it from wobbling. That was before they were divorced and Ammu came back to live in Kerala.
>
> According to Estha, if they'd been born on the bus, they'd have got free bus rides for the rest of their lives. It wasn't clear where he'd got this information from, or how he knew these things, but for years the twins harbored a faint resentment against their parents for having diddled them out of a lifetime of free bus rides. (Excerpt from *The God of Small Things* by Arundhati Roy.)

Arundhati is best known as a writer. She won the Booker Prize in 1997 for her book, *The God of Small Things*. (The Booker Prize is a major prize awarded for an excellent novel.) The book, set in the part of India where Arundhati grew up, is about a pair of young twins, Rahel and Estha. Their family life is hard, and they have to deal with life's twists and turns. Her novel was translated into thirty-three languages. It spent forty-nine weeks on the *New York Times* Bestseller List.

In the years since she published her first book, Arundhati has also become known as a peace activist. Her second book, *The Cost of Living*, contains political essays about India's nuclear weapons and government dam projects. The dams have forced millions of poor people to leave their homes. In 2002, she was

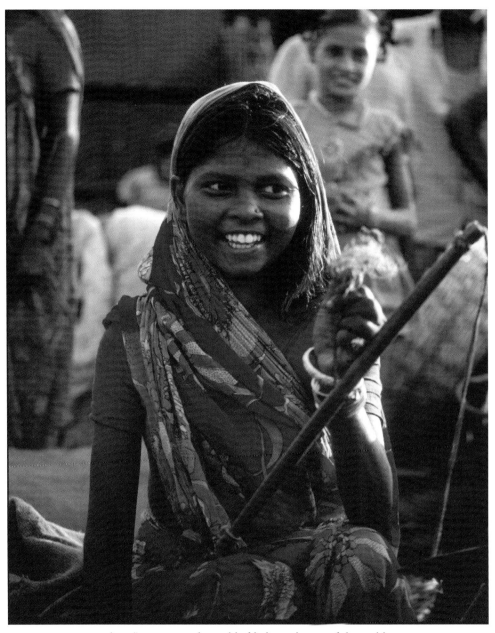

Arundhati portrays the world of India to the rest of the world.

WOMEN IN THE WORLD OF INDIA

held in contempt of court for saying that the court tried to keep people from protesting against one of those dams—but she was only sentenced to one day in jail. The sentence was more of a message than a punishment. She has also published two more political books, *War Talk* and *Power Politics*.

Arundhati, unlike many of the successful writers from India, still lives in her country. She tries to better the nation and has received worldwide recognition for her work.

"PROSTITUTION HAS ALWAYS THRIVED IN SUCH AREAS WHERE DEEP-SEATED POVERTY, UNEMPLOYMENT AND VULNERABILITY MINGLE TO FORM A POTENT BACKGROUND TO EXPLOITATION." —MEENA MENON

# LOOKING TOWARD THE FUTURE

Although Indian women have made great strides, they are still a long way from achieving equality with the men of India. A variety of issues continue to be important for the future of women in this diverse country.

> When Rani returned home from the hospital cradling her newborn daughter, the men in the family slipped out of her mud hut while she and her mother-in-law mashed poisonous oleander seeds into a dollop of oil and forced it down the infant's throat.
>
> As soon as darkness fell, Rani crept into a nearby field and buried her baby girl in a shallow unmarked grave next to a small stream.
>
> "I never felt any sorrow," Rani, a farm laborer with a weather-beaten face, said through an interpreter. "There was a lot of bitterness in my heart because the gods should have given me a son." ("The Burden of Womanhood: Third World, Second Class," *Washington Post*, April 25, 1993)

In India, each and every year, hundreds or maybe even thousands of girl babies are killed by their mothers because they are the wrong gender. Some

Indians believe that killing a baby girl will result in a boy the next time the woman has a baby. Other girls are killed because their parents know they would eventually have to pay a dowry for their daughters and few families can afford this expense. A woman who has lived a life of hardship might even kill her daughter to save her from a similar fate.

Female infanticide happens mostly in rural India. Although no one knows for sure how often it happens, signs indicate that it is quite common. The Community Services Guild of Madras, a city in southern India, surveyed 1,250 women and found that more than half those women admitted to killing baby daughters.

Upper-class women in Indian cities have more high-tech options to avoid having baby girls. Modern medicine allows women to determine whether they are carrying a boy or a girl early in a pregnancy. Some women decide to have an abortion when they discover they are going to have a girl. According to the *Washington Post* article cited above, clinics in the largest cities in India reported that, of 8,000 abortions that were performed after learning the sex of the baby, 7,999 were female fetuses. This is called selective abortion.

According to the Food and Agriculture Organization of the United Nations, there are ninety-three women to every hundred men in India. With India's huge population, that means that there are almost four million more men than women in India. Normally, the numbers of men and women are about equal; this serious difference is likely a result of female infanticide, selective abortion, and the neglect of female children.

On April 27, 1982, Mina married Kamlakar Bhavsar in Nasik, a town in southwestern India. She married with some anxiety but the high hopes for a happy marriage. She moved into the home of her new husband, nervous about finding her place with his parents and sisters.

Instead of the happiness, or even the contentment, of which Mina dreamed, she found that she was not as welcome in her new home as she

WOMEN IN THE WORLD OF INDIA

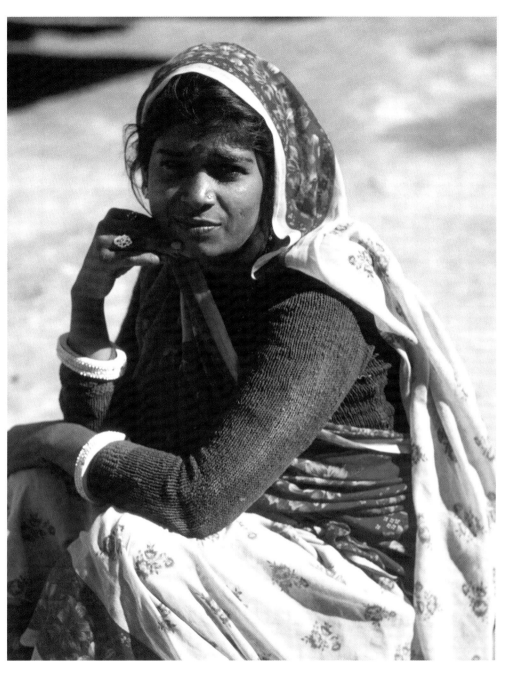

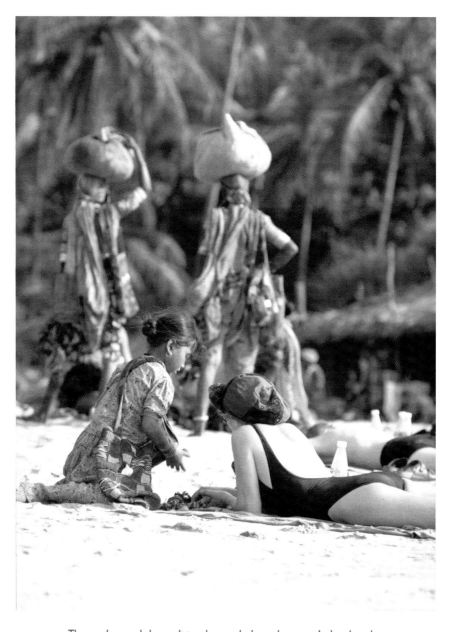

The modern and the traditional are side-by-side on an Indian beach.

WOMEN IN THE WORLD OF INDIA

had hoped. Mina's dowry was not as large as her husband's family would have liked. Her husband and his parents and sisters constantly harassed her, calling her names and insulting her. Soon they went beyond name-calling and began to beat her.

Mina was one of the strong ones. She didn't stand for this as many Indian women would have. Instead, she packed up her belongings and left her new home. She even filed a case against her husband for harassment.

Indians are not kind to women who leave their husbands. Eventually, Mina began to question her decision. When her in-laws invited her to their home to worship, she decided to take them up on their offer.

Mina did not leave their home alive. Her in-laws reported that she "fell on a fireplace." She suffered burns over 94 percent of her body and did not survive her injuries. (Adapted from "Rooted Together" by Kalpana Sharma, indiatogether.org)

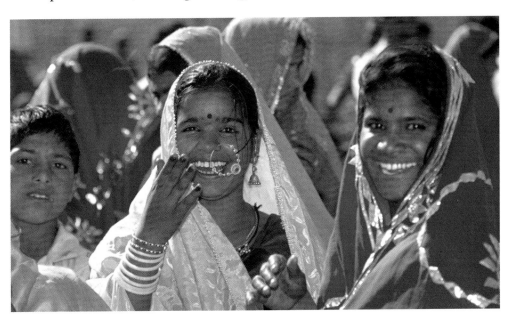

Indian girls today still face many challenges.

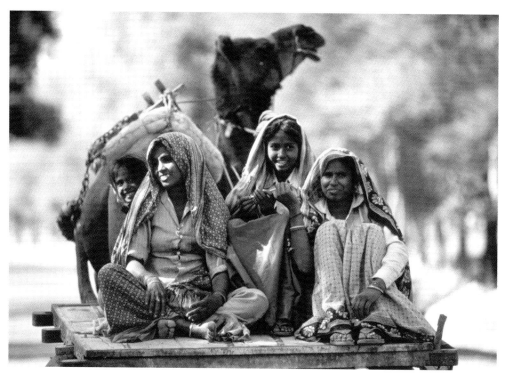

When these young women marry, they may be expected to pay dowries to their husbands.

The dowry system remains one of the most *controversial* traditions in most of India. Sometimes, when a woman fails to meet the dowry demands of her husband, she may be killed in what has been called "bride burning"—the new bride is covered in cooking oil and set on fire by her husband or her mother-in-law. The burning is made to look like an accident to avoid legal problems.

This practice has been a serious problem in India for a number of years. Officials believe that as many as one thousand young brides fall victim to this crime each year in India's capital city alone. The Indian Home Ministry reports more than 6,000 of these deaths each year. This is in spite of the fact that demanding a dowry has been illegal in India since 1995. Activists believe that the

WOMEN IN THE WORLD OF INDIA

actual numbers of deaths are much higher, since many of the deaths are recorded as suicides or accidents.

The dowry system was first created in ancient India as a way to help newly-wed couples start their lives together. Many people believe that it has become more of a way for men to make a small fortune. These killings and the harassment that women often suffer from their husband's families are made worse by other social conditions in India. There is social pressure for women not to leave their husbands. Most women could not afford to live on their own even if they dared to do so. They have a hard time getting good jobs and are very poor. In fact, they are some of the poorest people in the world. Many of the jobs they are allowed to work are very low paying. Some of the jobs are actually not paid at all; the women that work these jobs get paid with food and shelter instead of money. The difference in pay between women and men forces many women to stay in abusive homes.

❀ ❀ ❀

Thirteen-year-old Teji went out in the morning to start her daily tasks. She cleaned the front step and drew the protective kolam in the soil. She collected her water bucket and headed for the community water pump. She had been doing this every day for eight years, ever since she was old enough to pick up the bucket and walk to the pump on her own. The other women smiled at Teji and offered blessings to her as she started her walk back home with the full bucket. This confused her, because the older women usually ignored her. Perhaps she was finally starting to come of age in their eyes. She was surprised to see her father and mother standing in front of their home when she returned. They almost never went outside until after she had finished her morning tasks. There was a man she did not know talking with her parents. She put the water bucket down in its place. Her father called her over. "Teji" he said, "come here." Teji was an obedient girl. She went to her father. "Teji, you are to go with this man. He will be your father now."

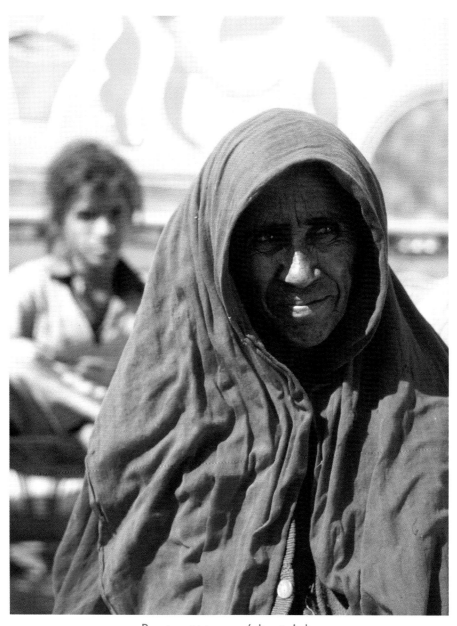

Poverty restricts women's lives in India.

WOMEN IN THE WORLD OF INDIA

Teji was shocked. Who was this man? Where was he going to take her? She looked to her mother, who looked sad. Teji was very confused and scared. She could not understand why her parents were sending her away, but she knew she must go. There was no arguing with her father. Teji gathered her few belongings and walked out of the house. The man handed Teji's father an envelope and then took her by the hand and lead her down the street to his truck. She had never been in a truck before. They rode in the truck for many miles. The man did not speak to her. They did not stop until well into the night. They drove into a city. This was exciting to Teji, who had never seen the city before.

They stopped at a large building with a bright sign hanging in the window. Teji could not read, so she had no idea what the sign said. There were women standing outside, and much of their skin was exposed! Teji was shocked that these women would ignore purdah like this. The man took her inside the building. He said "Welcome to your new home."

Teji's parents were very poor. They had sold her to a sex trafficker. She lived for a year in a *brothel* in India, and was sold to a man from another country. Shortly after this, she jumped to her death from the roof of a building. Teji had found a way to escape.

❀ ❀ ❀

The poverty in India sometimes forces people to do things they might not want to, just to survive. Prostitution is not illegal in India. As long as a woman is over eighteen years old, she is allowed by law to sell herself. Many women sell sex in order to get the money they need. Indian law sets the minimum age for prostitution, but that does not stop some people from forcing younger women into prostitution. Sex trafficking, or the illegal sale of women and girls against their will, is a serious problem. Sometimes, very poor families will sell their daughters in order to pay their bills. Other times, the trafficker will trick the girls or kidnap them.

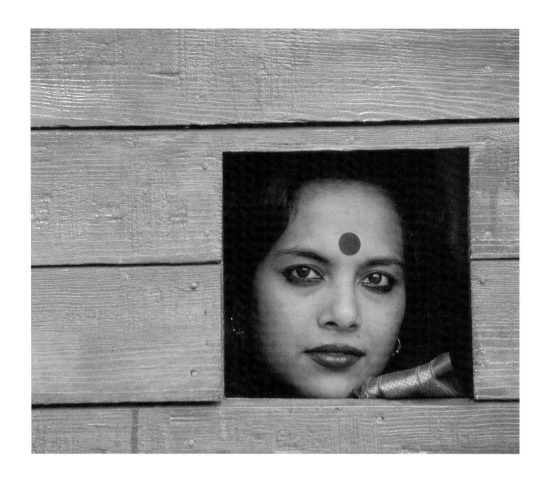

Most of the girls are taken to other countries after they are sold. This makes it very difficult for them to escape. They may spend their entire lives as sex slaves. Some of the girls are allowed to buy their freedom, but it may take them many years to save enough money to do this. By the time they can, most are infected with diseases. Many of the girls will commit suicide. Some try to escape. Girls that are caught trying to escape are badly beaten. Even if a girl does escape, where is she to go? She has no citizenship papers, and may not be able

WOMEN IN THE WORLD OF INDIA

Sex trafficking has led to an increase in the spread of HIV, the virus that causes AIDS. In India and other poor countries, AIDS is a serious problem. The spread of AIDS has not affected the demand for prostitutes in India. Actually, it has caused sex traffickers to get younger girls that have less chance of having AIDS. Some men will actually pay more for younger girls because of the lower risk of infection. The spread of AIDS is a problem that is gaining more and more attention from the more developed countries of the world. With the increased attention, there is pressure to change the sex industry of India

to get out of the country to which she was taken. Most of the girls that escape die on the streets from starvation.

There are several organizations that are trying to make life better for the women of India. The United Nations has gotten more and more involved. In 1989, the UN passed a policy known as the Convention on the Rights of the Child that protects children from sale and slavery. In India, there is a special commission that exists only to find ways to protect women. The National

Commission on Women (NCW) is a panel of highly educated Indian women. They examine the laws of the country and look for new ways to help women. Much of the new policy created by the Indian Parliament has been enacted because of the demands and pressure of the NCW.

With the help of agencies like these, courageous women in India are finding ways to change their lives. They look toward the future with hope—but they have many obstacles to overcome. Many of them may never see a better future—but hopefully, their daughters will.

# FURTHER READING

Bumiller, Elisabeth. *May You Be the Mother of a Hundred Sons: A Journey Among the Women of India*. New York: Random House, 1990.

Butler, Francelia. *Indira Gandhi*. New York: Chelsea House Publishers, 1986.

Cifarelli, Megan. *India: One Nation, Many Traditions*. New York: Benchmark Books, 1996.

Fuller, C.J. *The Camphor Flame: Popular Hinduism and Society in India*. New York: Columbia University Press, 1992.

Ganguly, Sumit and Neil DeVotta. *Understanding Contemporary India*. London: Lynne Rienner Publishers, 2003.

Goodwin, William. *India*. San Diego, Calif.: Lucent Books, 2000.

Harrison, Selig S., Paul H. Kreisberg, and Dennis Kux (eds.). *Mother India: A Political Biography of Indira Gandhi.* New York: Charles Scribner's Sons, 1992.

Henderson, Carol. *Culture and Customs of India*. Westport, Conn.: Greenwood Press, 2002.

Kingsland, Venika. *The Simple Guide to Customs & Etiquette in India*. Kent, England: Global Books Ltd., 1996.

Koul, Sudha. *Come with Me to India*. Pennington, N.J.: Cashmir, Inc., 1997.

Nyrop, Richard F. *India, A Country Study*. Washington, D.C.: U.S. Government Printing Office, 1986.

Rodgers, Mary M (ed.). *India in Pictures*. Minneapolis, Minn.: Lerner Publications Company, 1995.

Srinivasan, Radhika and Rodbika. *India*. Tarrytown, N.Y.: Benchmark Books, 1994.

Swan, Erin Pembrey. *India: Enchantment of the World*. New York: Children's Press, 2002.

Wagner, Heather Lehr. *People at Odds: India and Pakistan*. Philadelphia, Penn.: Chelsea House Publishers, 2002.

# FOR MORE INFORMATION

Adventure Divas: India
www.pbs.org/adventuredivas/india/

BollyWHAT?! The Guide for Clueless Fans of Bollywood Films
www.bollywhat.com/

Dichotomies in Indian Women's Lives
www.aliciapatterson.org/APF2003/Wells/Wells.html

Images of India
www.geocities.com/Tokyo/Shrine/4287/

India—A Country Study
lcweb2.loc.gov/frd/cs/intoc.html

Kamat's Potpourri: The Women of India
www.kamat.com/kalranga/women/index.htm

Library of Congress: Portals to the World: India
www.loc.gov/rr/international/asian/india/india.html

SD People: Asia's Women in Agriculture, Environment and Rural Production:
India
www.fao.org/sd/WPdirect/WPre0108.htm

Self Employed Women's Association
www.sewa.org/

Women's Status in Colonial and Present Day India
www.saxakali.com/Saxakali-Publications/recastgwm2.htm

World Factbook: India
www.odci.gov/cia/publications/factbook/geos/in.html

Publisher's note:
The Web sites listed on these pages were active at the time of publication. The publisher is not responsible for Web sites that have changed their addresses or discontinued operation since the date of publication. The publisher will review and update the Web sites upon each reprint.

# GLOSSARY

*activists* People who support a doctrine or practice emphasizing direct vigorous action, especially in support of or opposition to one side of an issue.

*brothel* bordello; a building in which prostitutes are available.

*caste system* The hereditary social classes in Hinduism that restrict the occupation of members and association with members of other castes; it is based on differences of wealth, inherited rank or privilege, and profession.

*controversial* Of, relating to, or arousing a discussion marked by the expression of opposing views.

*divas* Leading women.

*dowry* The money, goods, or property that a woman brings to her husband in marriage.

*ethnic groups* Large groups of people classed by common national, racial, religious, tribal, linguistic, or cultural background.

*globalization* The process of making worldwide in scope or application.

*harassed* Persistently annoyed.

*infanticide* The killing of an infant.

*literacy* The quality or state of being able to read and write.

*monsoons* The periodic rainfalls associated with the season of the heavy southwest rainfalls in India and adjacent areas.

*nationalism* Loyalty to a nation, especially a sense of national consciousness that places one nation above all others, primarily emphasizing promotion of its interests and culture as opposed to those of other nations.

*oppressive* Unreasonably severe; tyrannical.

*peace activist* A person who practices or supports direct action promoting peace.

*plague* An epidemic of a virulent, contagious febrile (feverish) disease that causes high mortality.

*Sanskrit* The ancient Indo-Aryan language that is the classical language of Hinduism and India.

*subjected* To be forced to endure something.

# INDEX

# PICTURE CREDITS

Cover: Studio1, Benjamin Stewart, Corel, Corel
Corel: pp. 12, 15, 16, 17, 18, 20, 22, 31, 32, 36, 37, 38, 40, 42, 44, 48, 50 52, 53, 54, 55, 60, 62, 63, 65, 66, 69, 70, 76, 79, 80, 83, 84, 86, 88, 95, 96, 97, 98, 100, 102.
Photos.com: 27, 30, 61

# BIOGRAPHIES

William and Miranda Hunter live near Buffalo, New York. William graduated from Fredonia University with a bachelor of science degree and the University at Buffalo with a master of arts degree. Miranda received her undergraduate degree from Geneva College and a law degree from the University at Buffalo School of Law. The Hunters have both recently changed careers to become high school teachers.

Dr. Mary Jo Dudley is the director of Cornell University's Gender and Global Change Department, which focuses on the evolving role of gender around the world. She is also the associate director of Latin American Studies at Cornell.